Cunt Face

Hilarious Sweary Coloring Book

Fun, stress Relief
By

S.B. Nozaz

Copyright © 2016 by S.B. Nozaz

All rights reserved worldwide. No part of this publication may be reproduced or distributed in any form or by any means, mechanical, electronic or stored in a retrieval or database system, without written permission from the copyright holder.

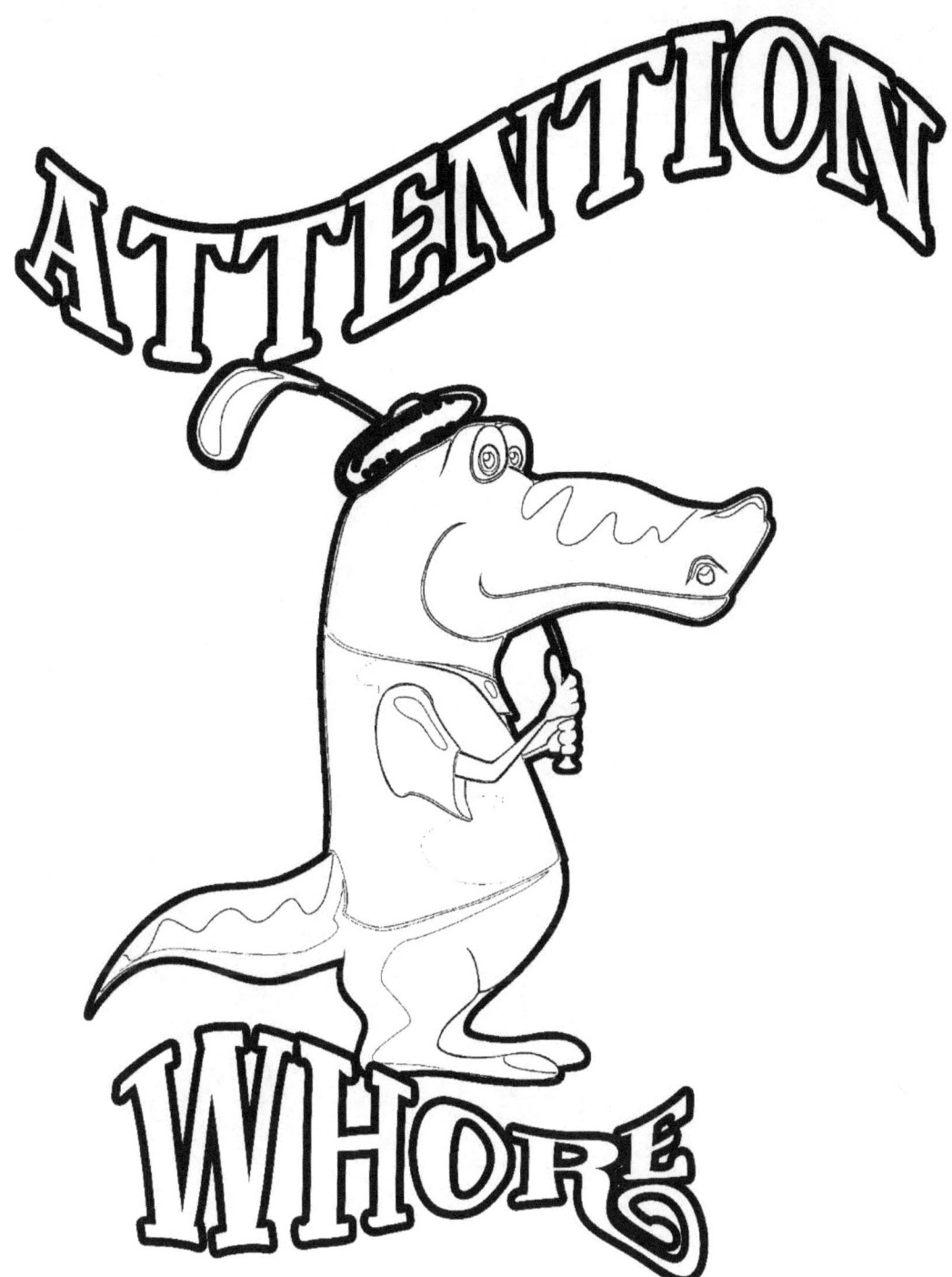

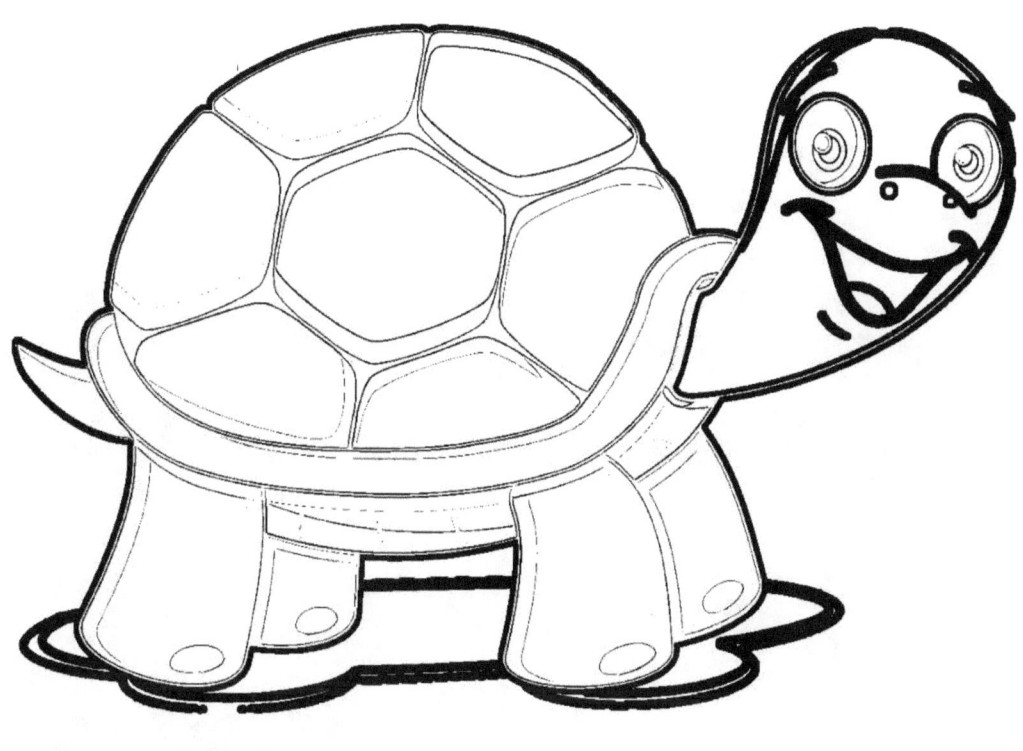

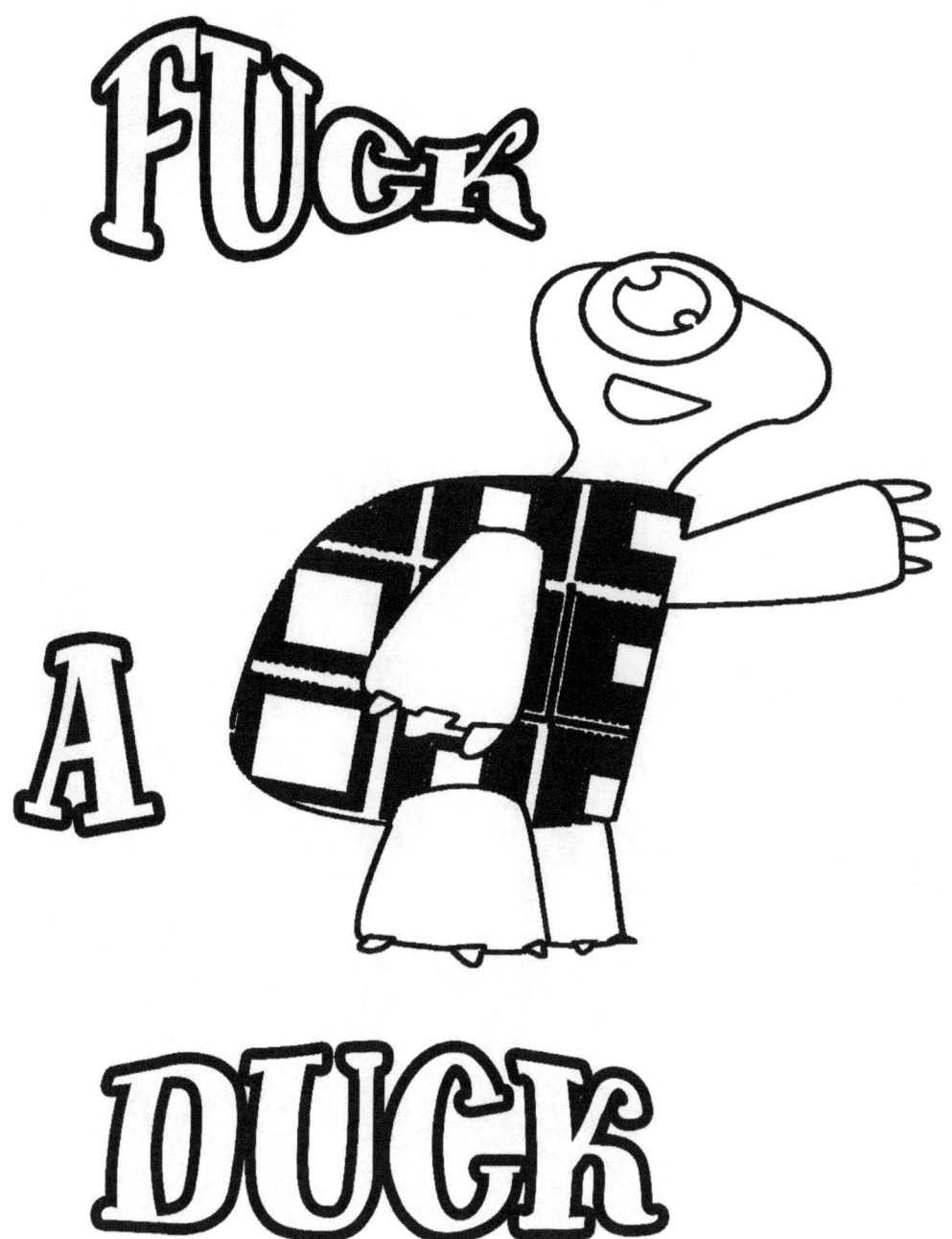

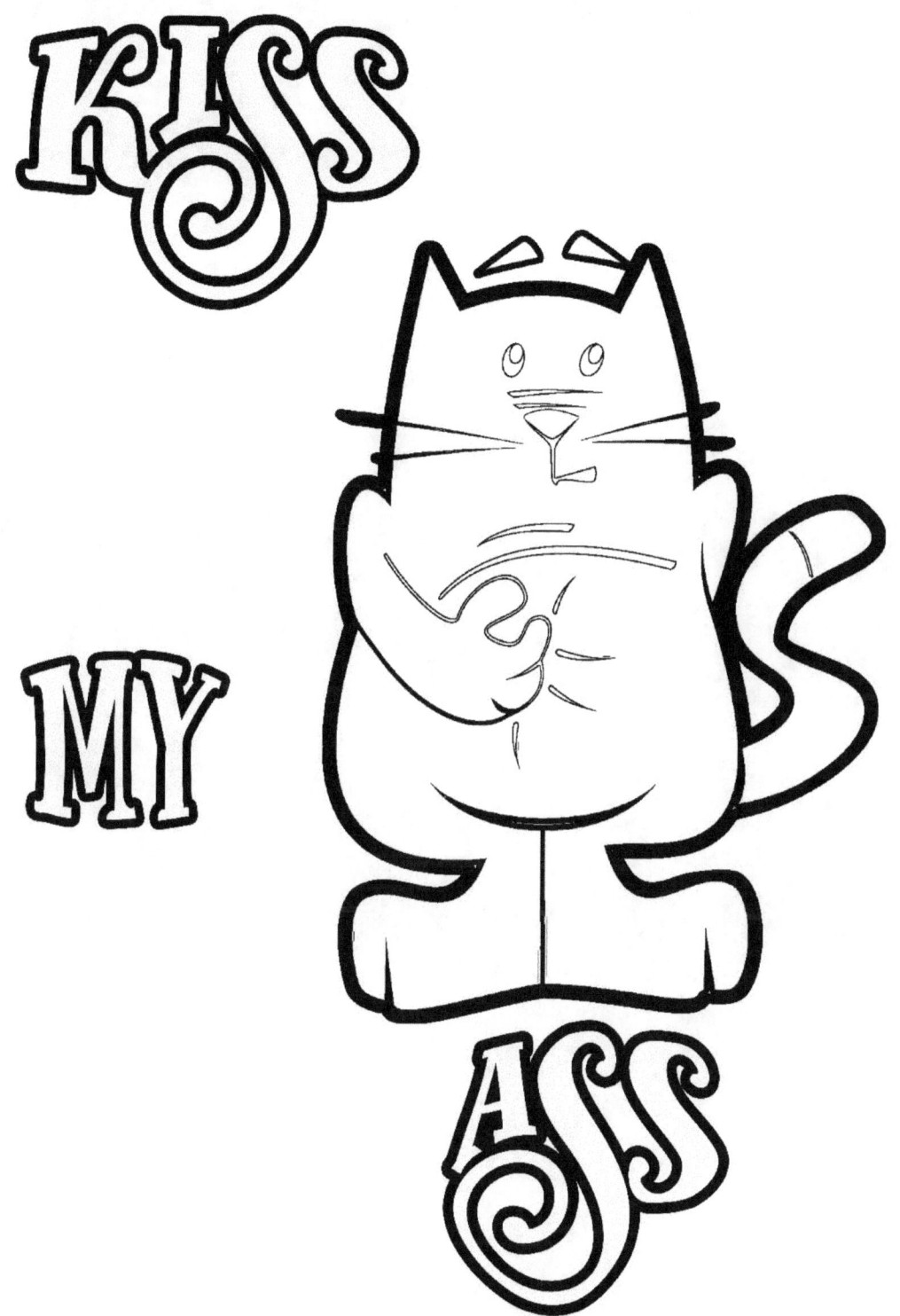

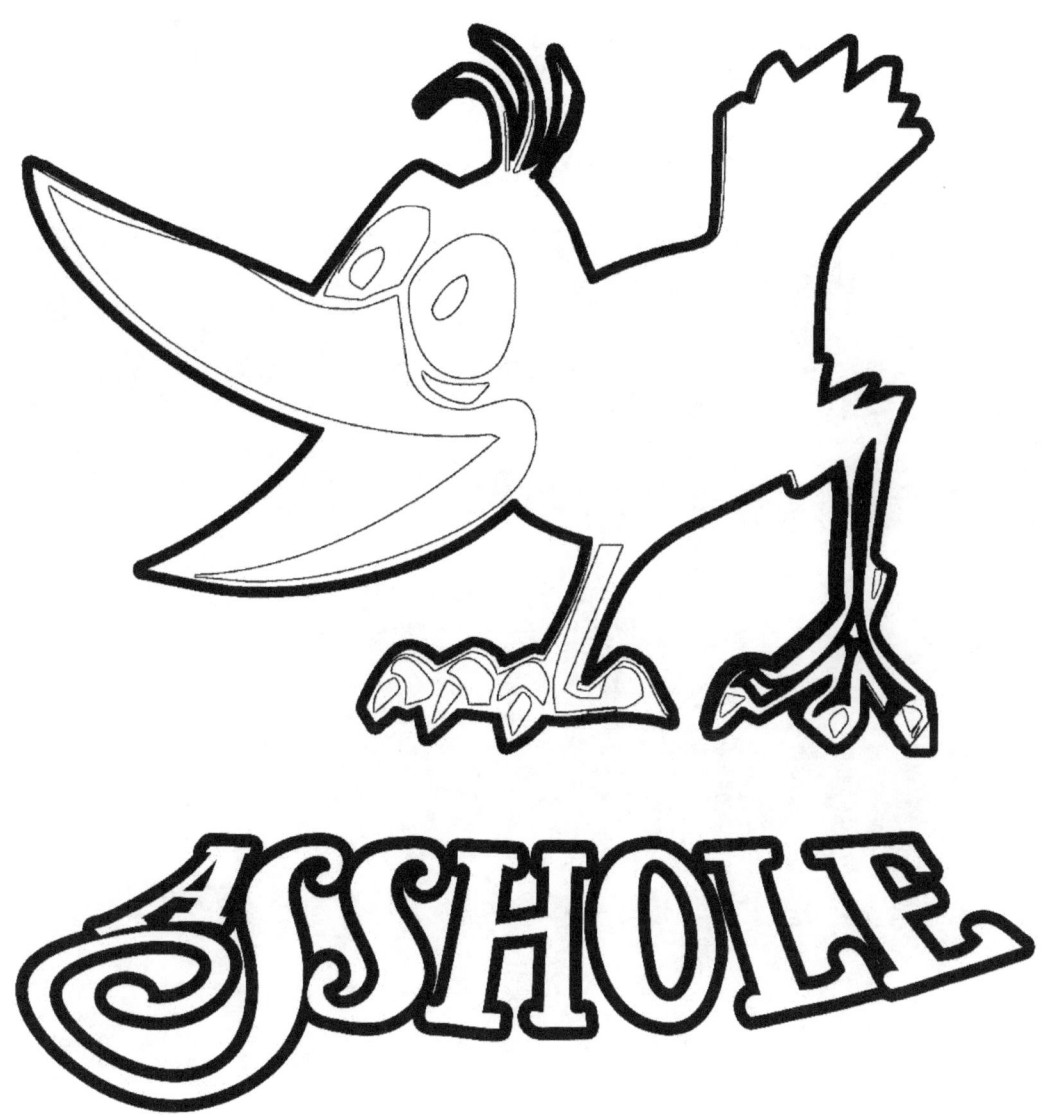

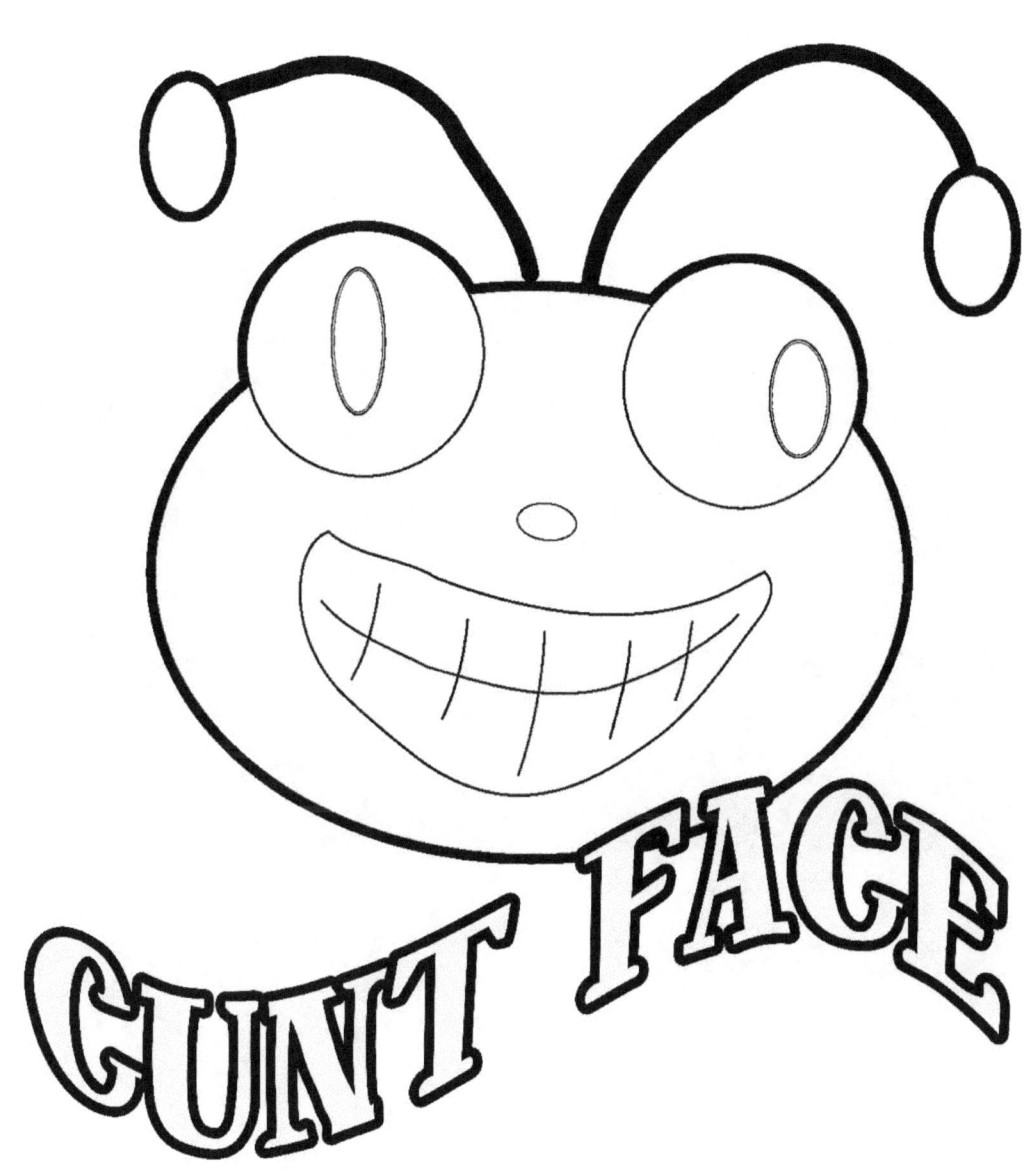

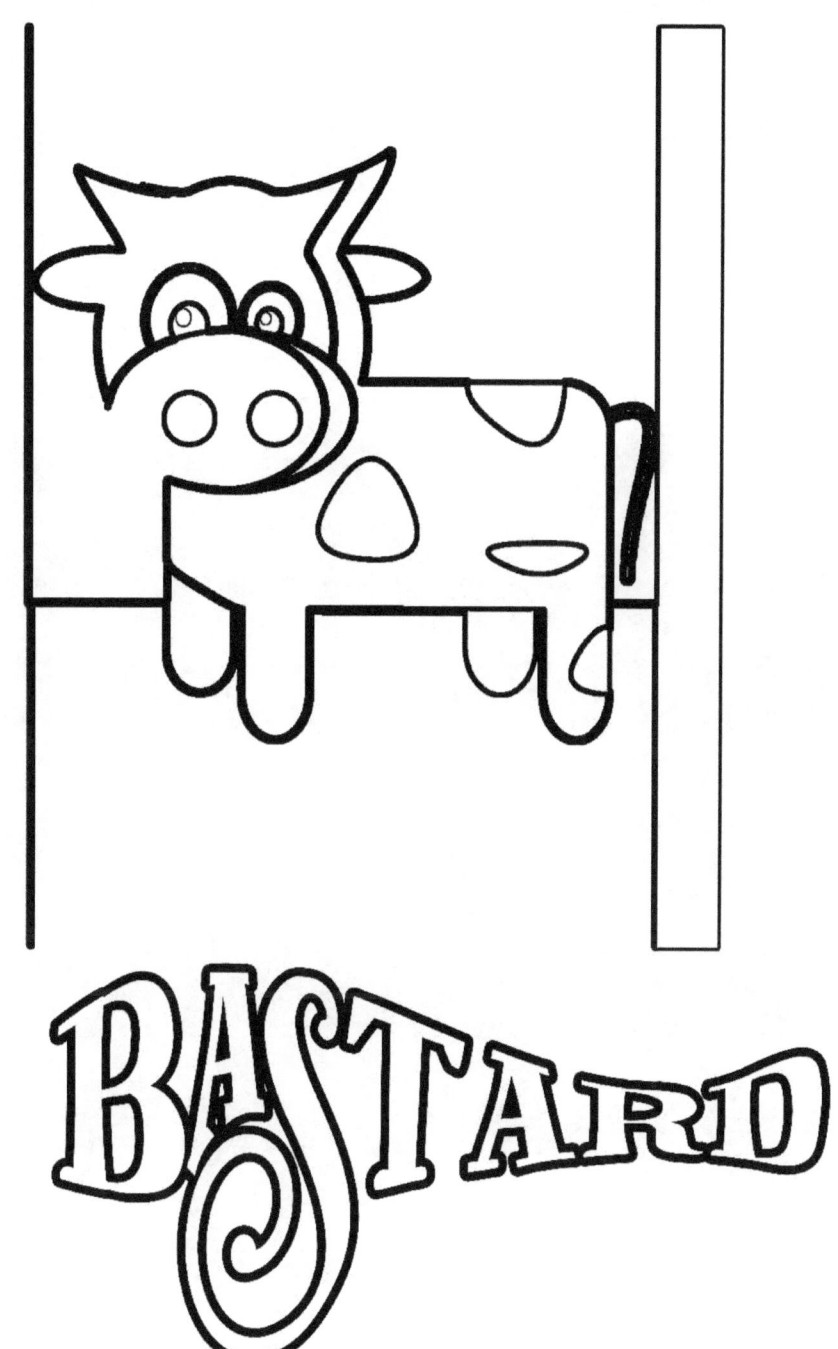

WHORE

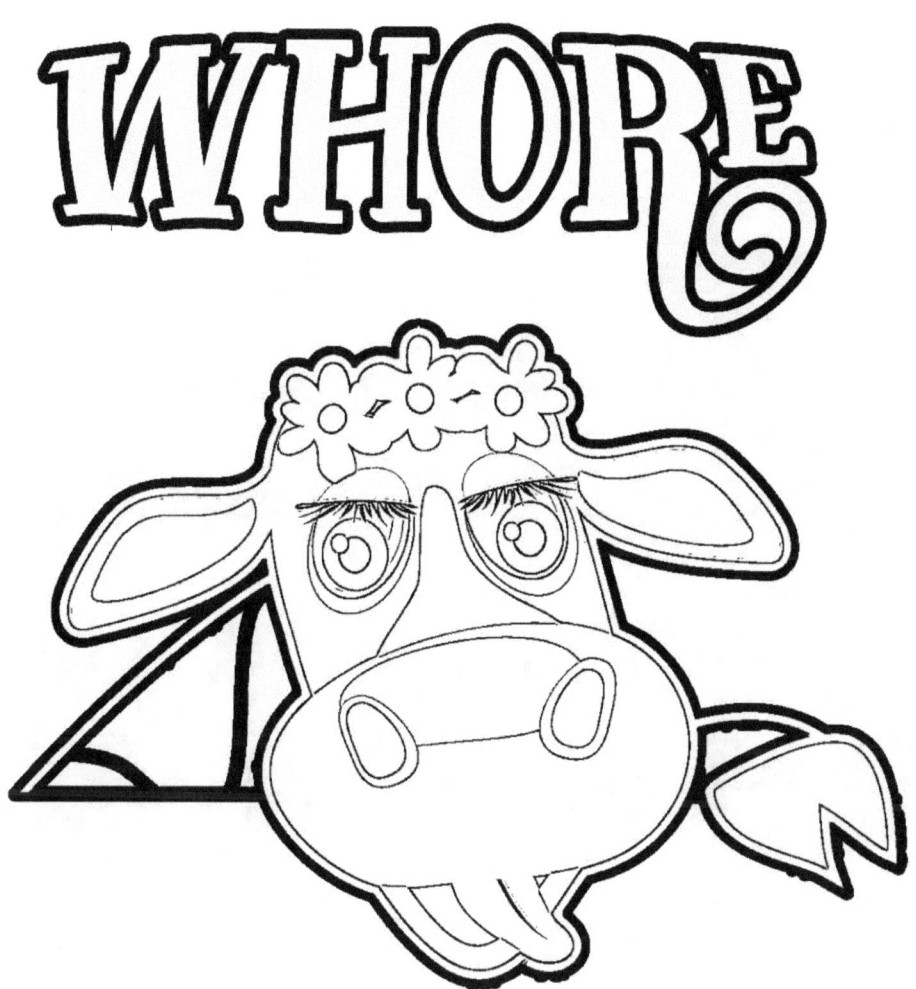

BATSHIT

CRAZY

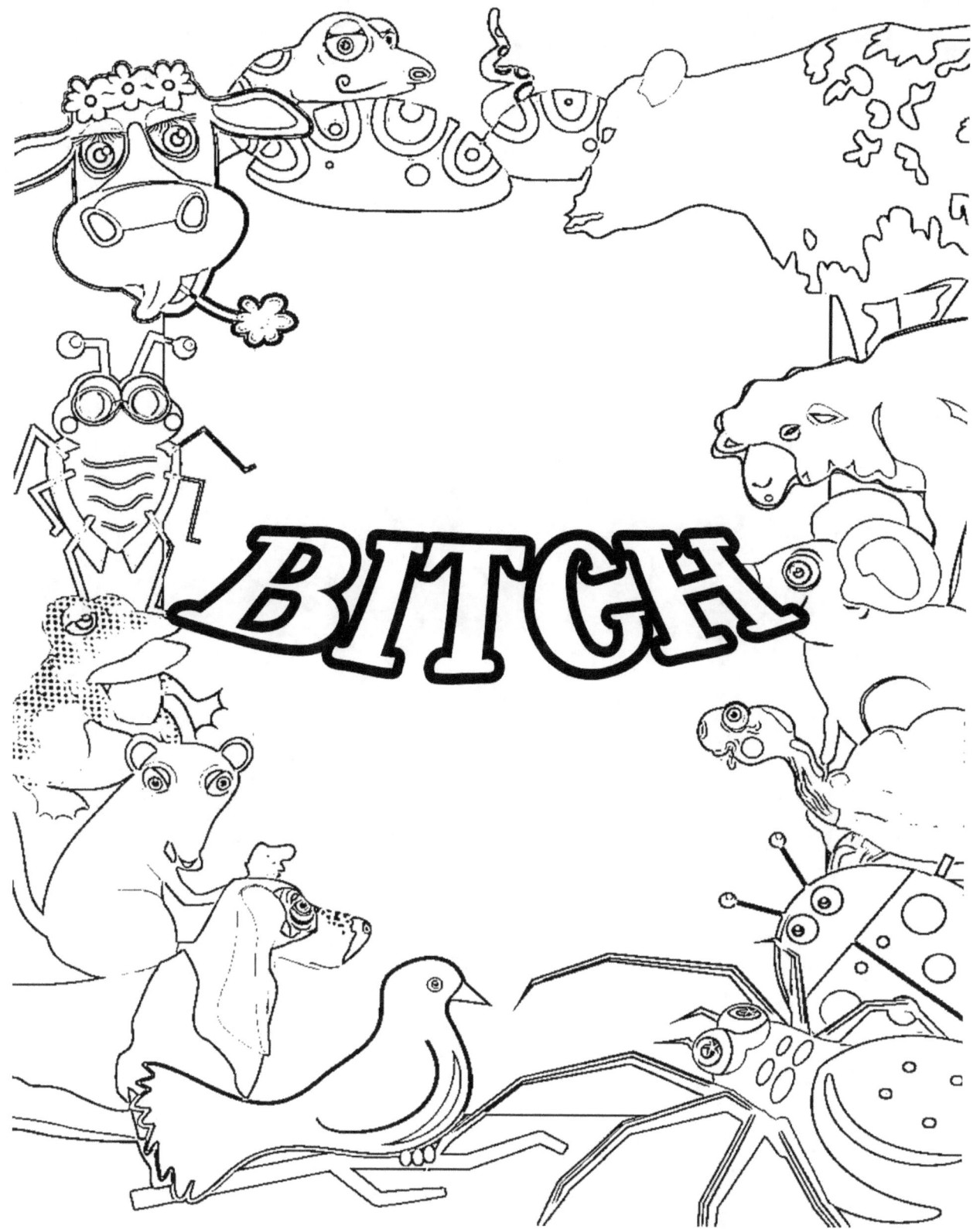

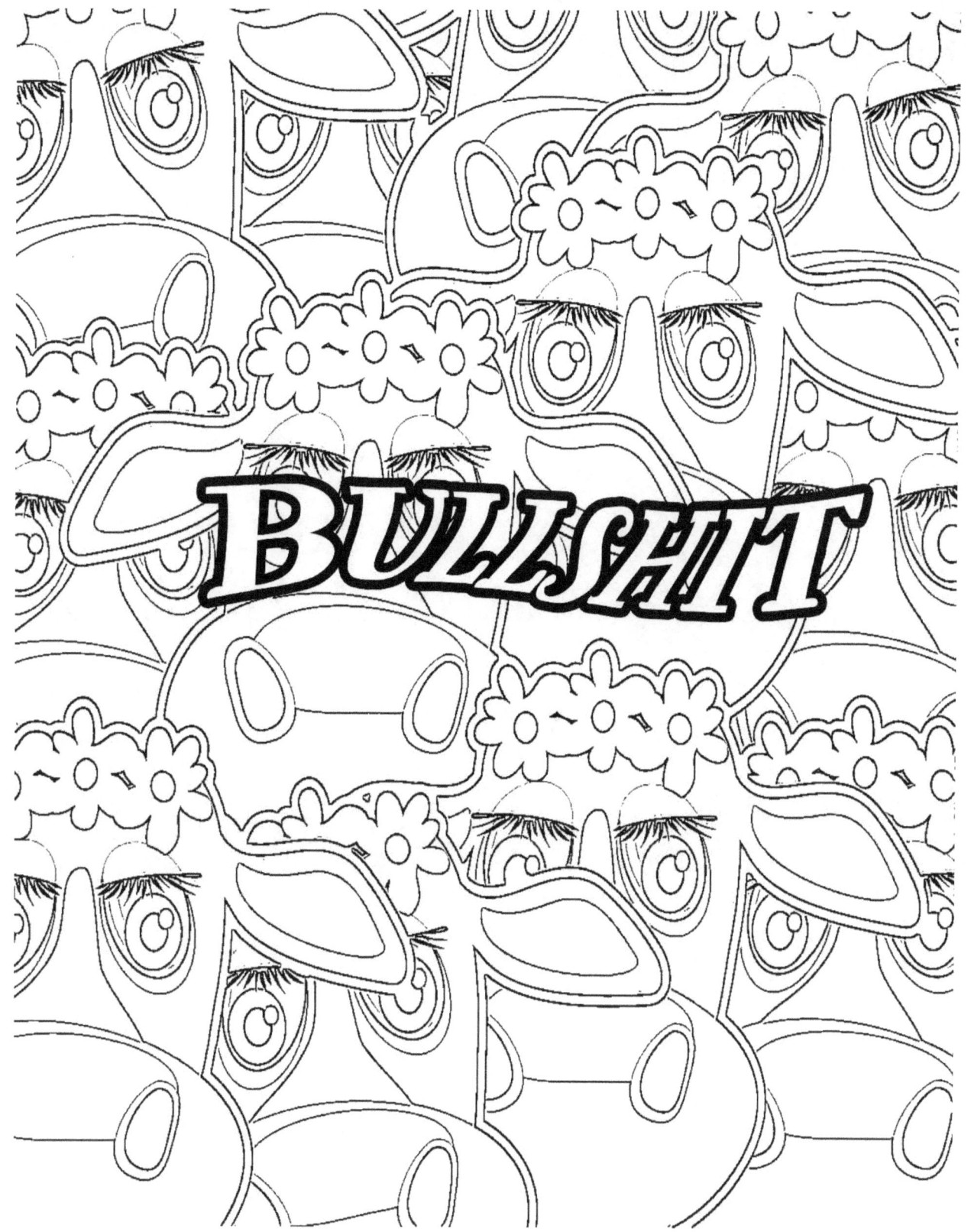

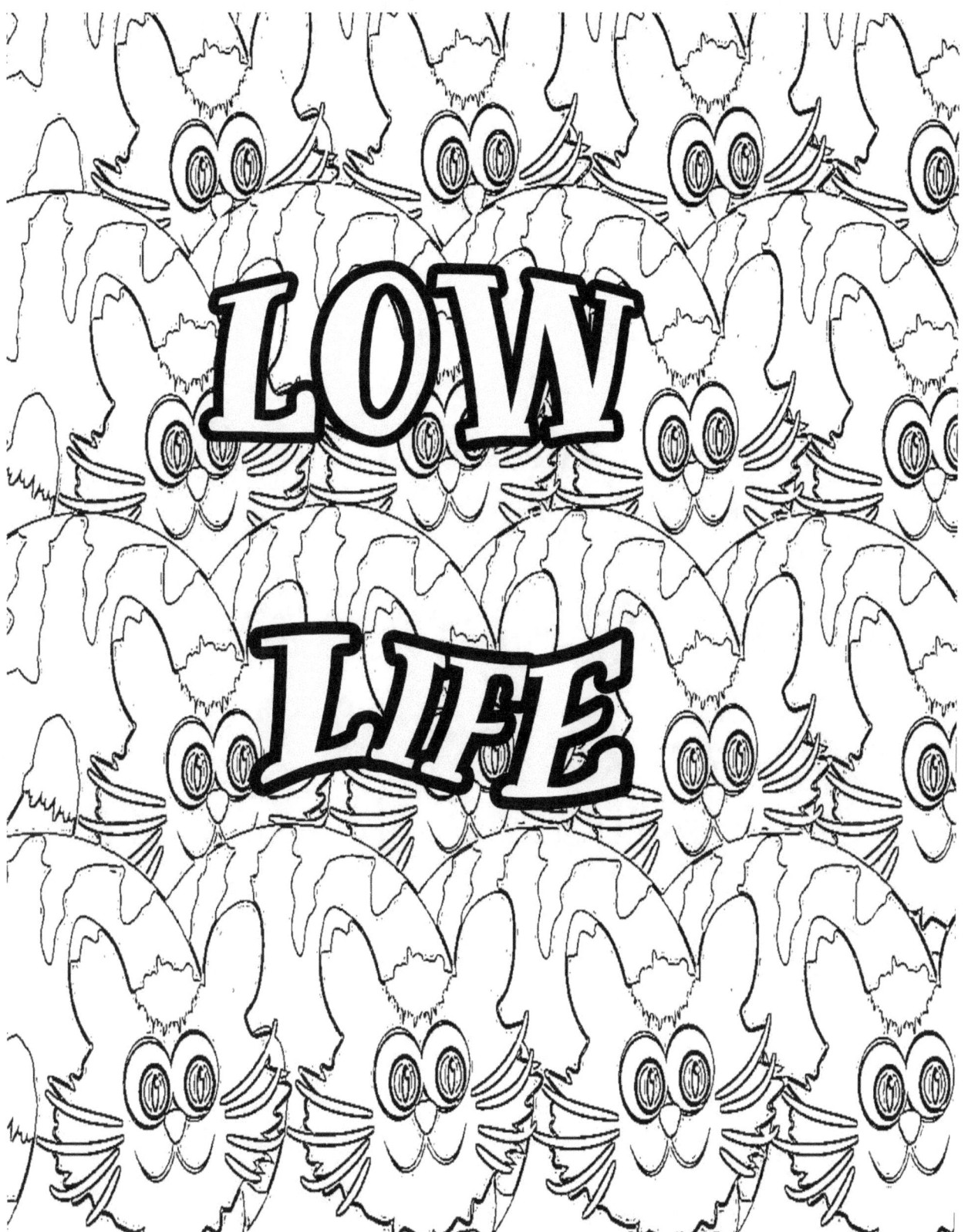

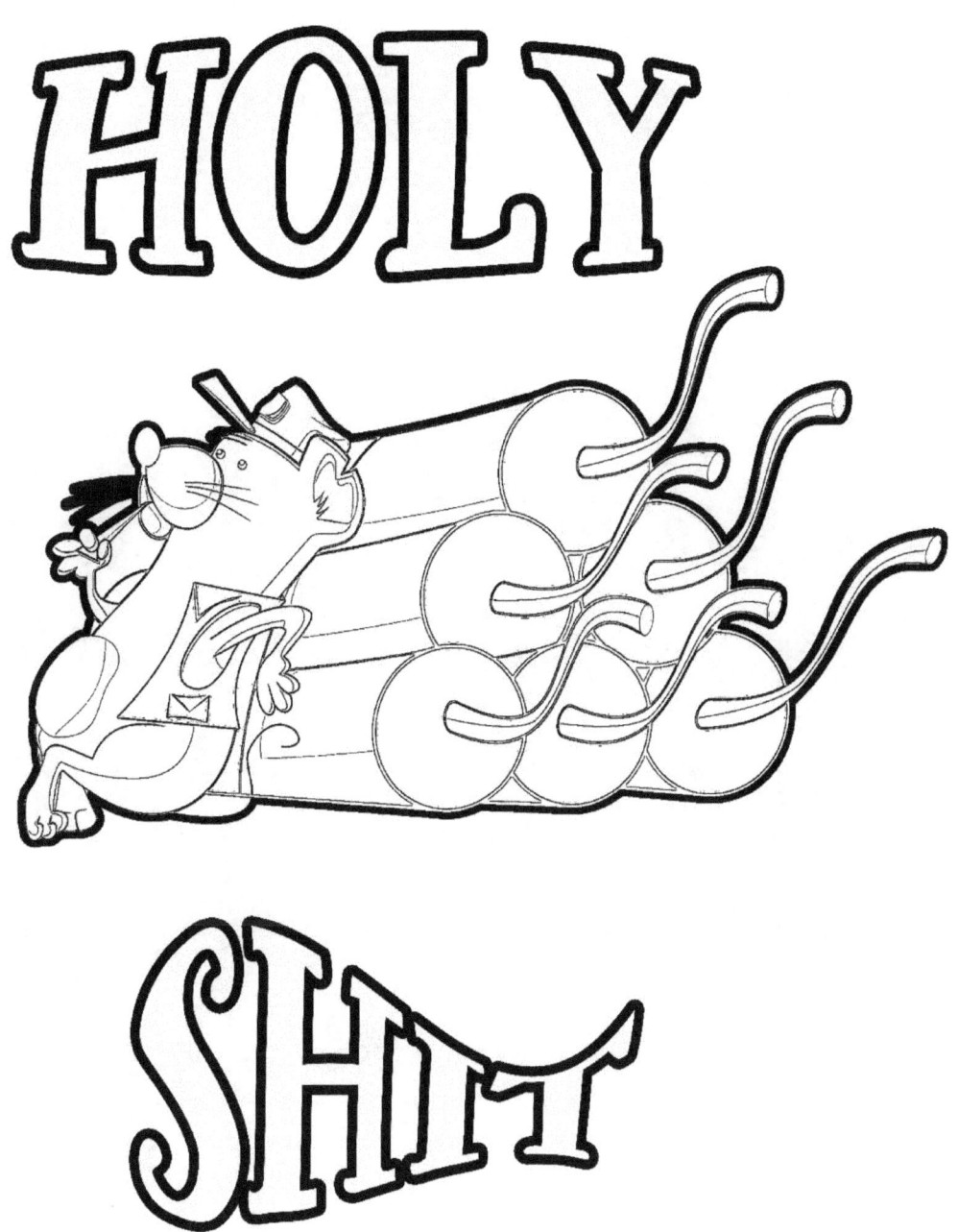

UGLY BIG SHOES

HOLLY FUCK

Note

www.ingramcontent.com/pod-product-compliance
Lightning Source LLC
Chambersburg PA
CBHW080635190526
45169CB00009B/3400